EAT A BAG OF DICK!
Coloring Book

Cussing Coloring Book for Adults, Swear Words For Stress Relief and Relaxation

30 Coloring Pages Designs

I0402217

Marsha Hebert

ISBN: 9781699782385

This Coloring Book contains adult language.
NOT FOR CHILDREN.
The dirty coloring books for adults both of women and men.

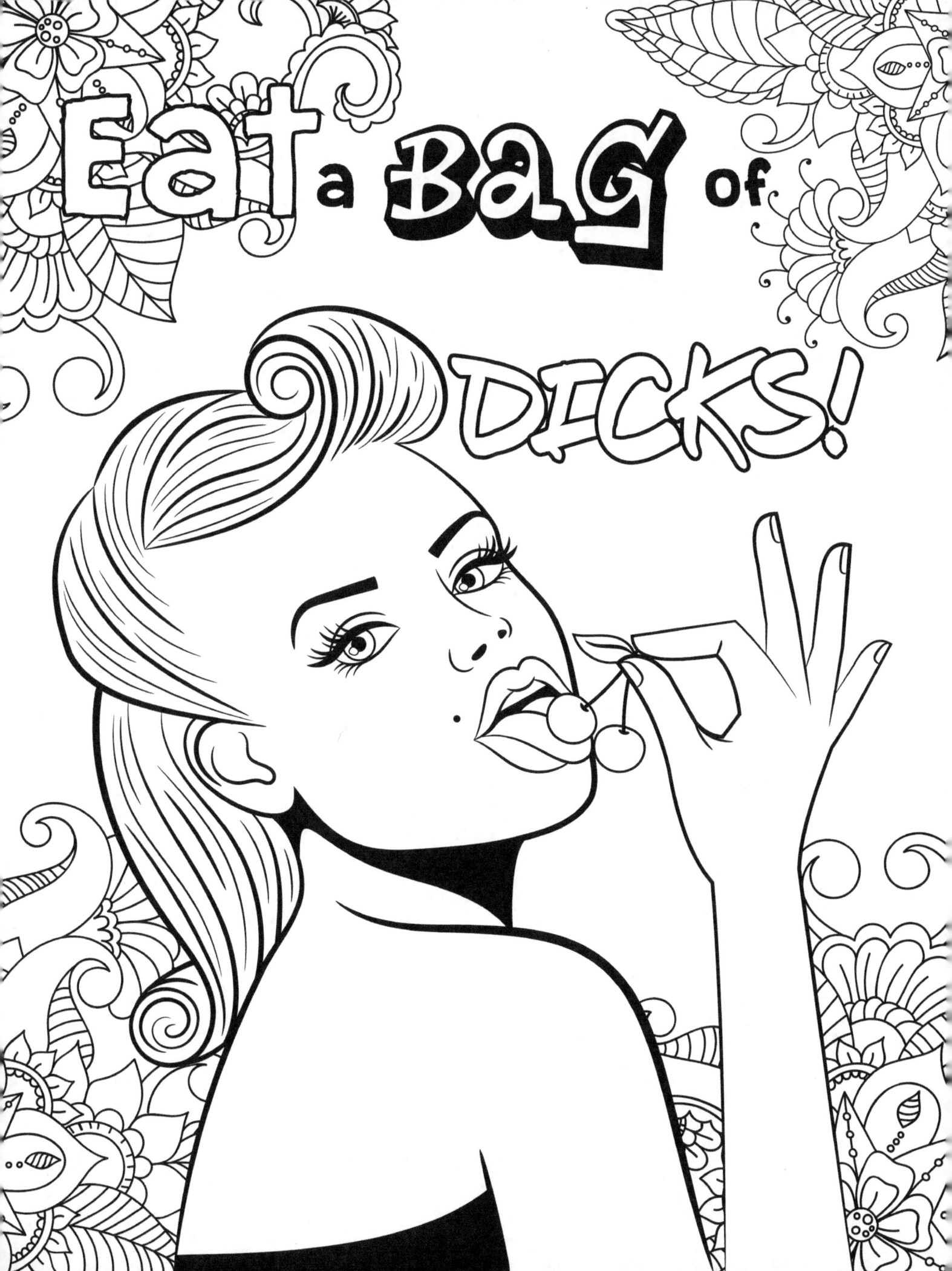

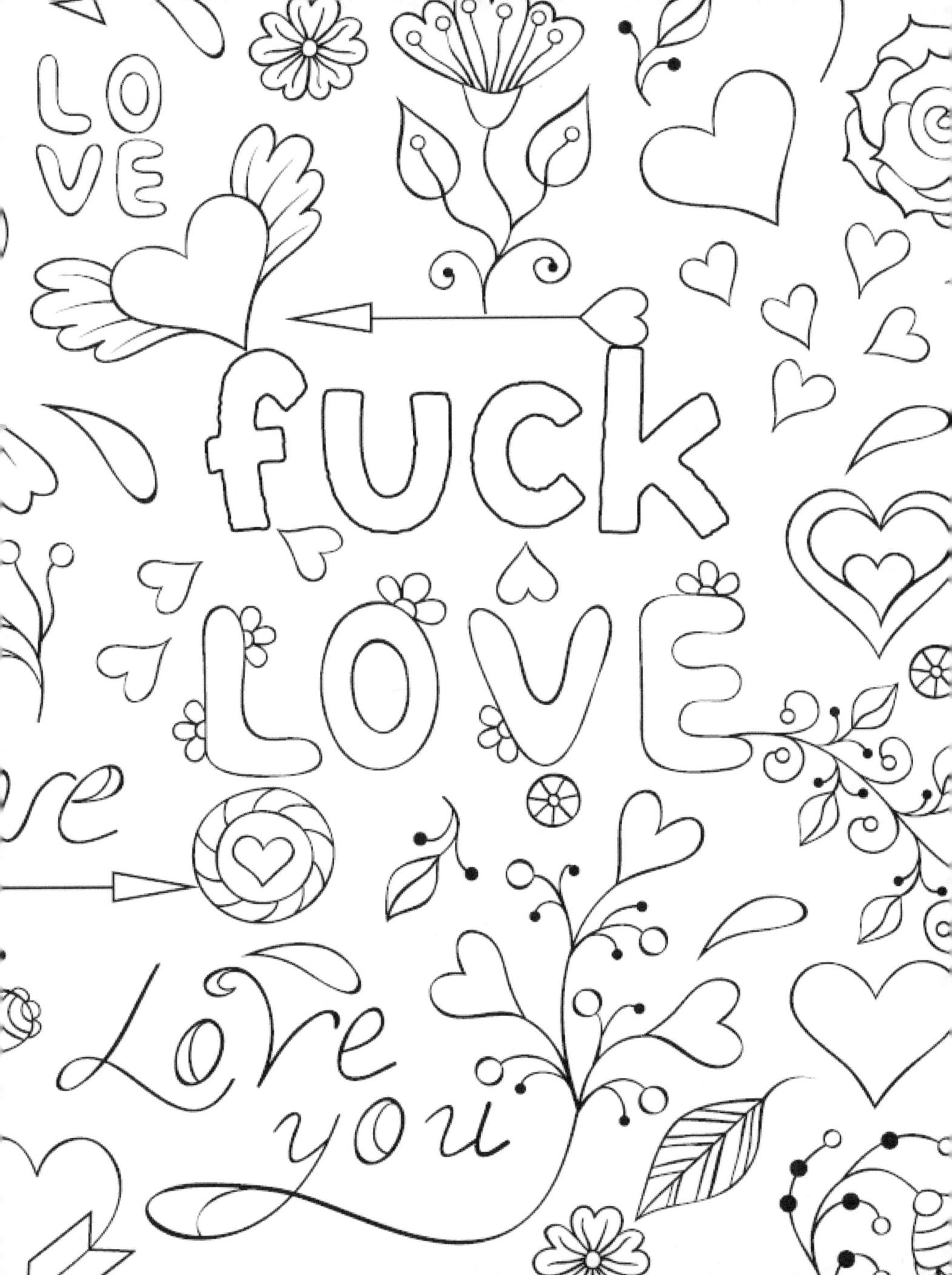

I do what I fuking want

CARPE that *fucking* DIEM

Follow your fucking bliss

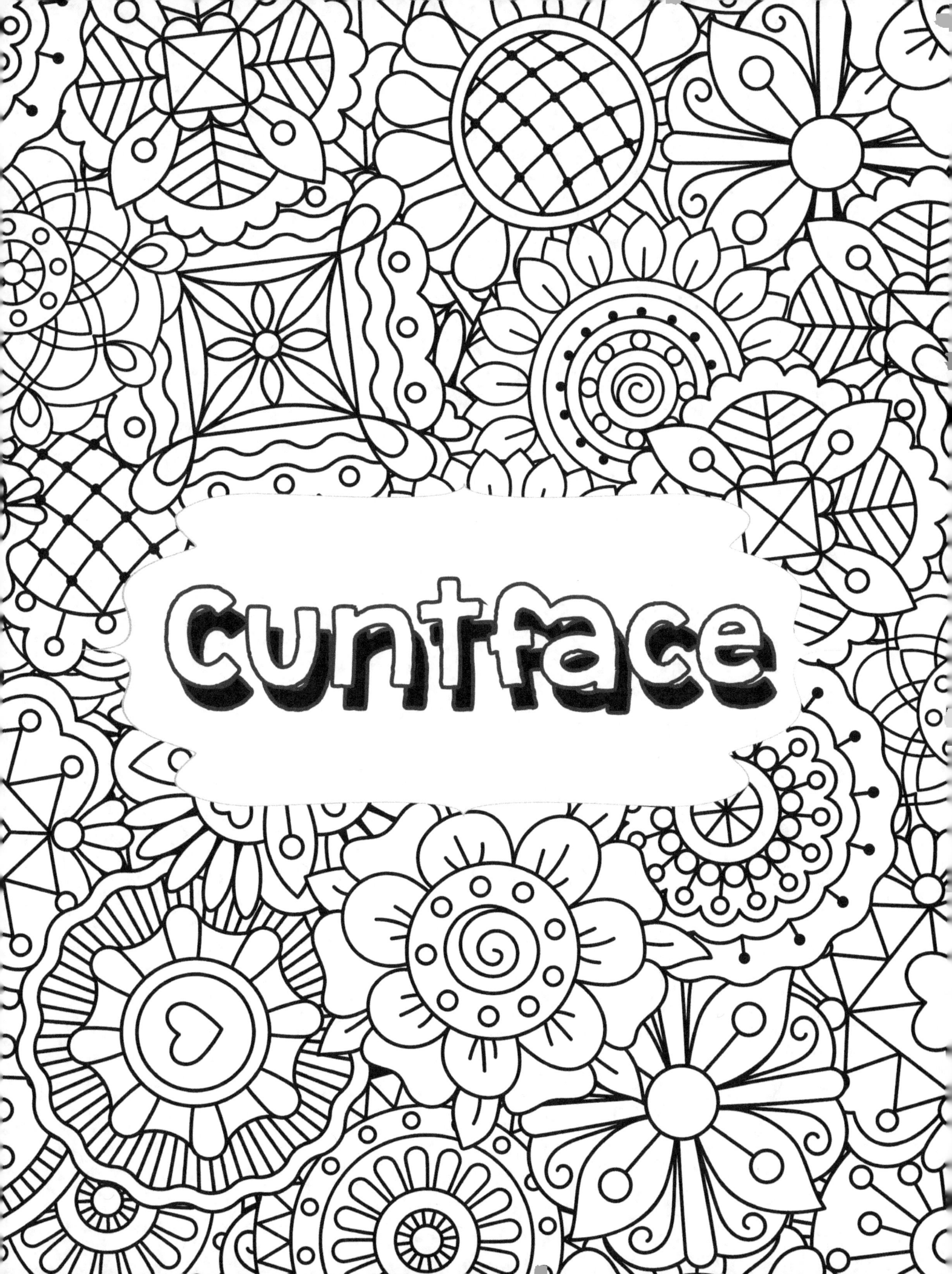

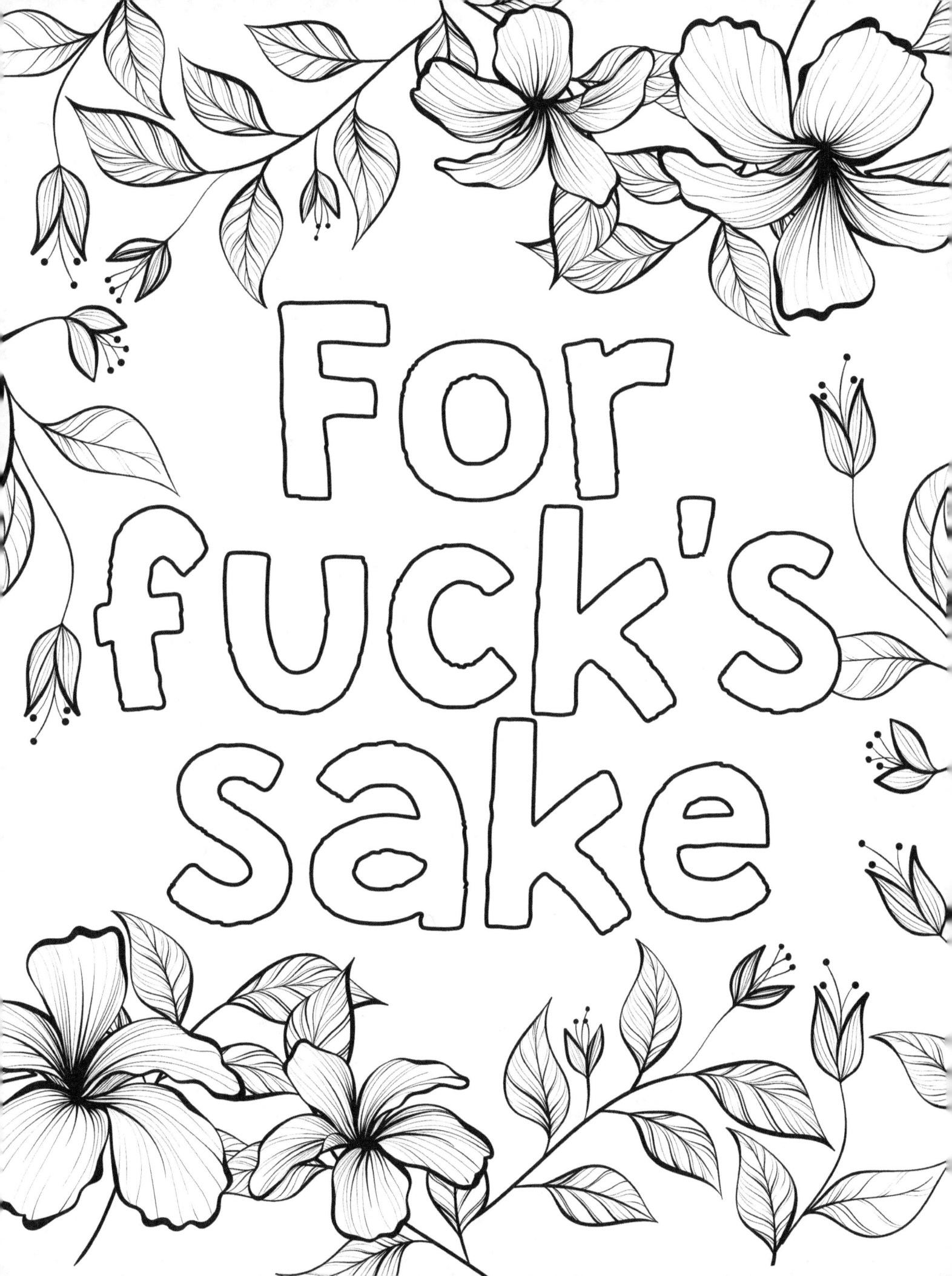

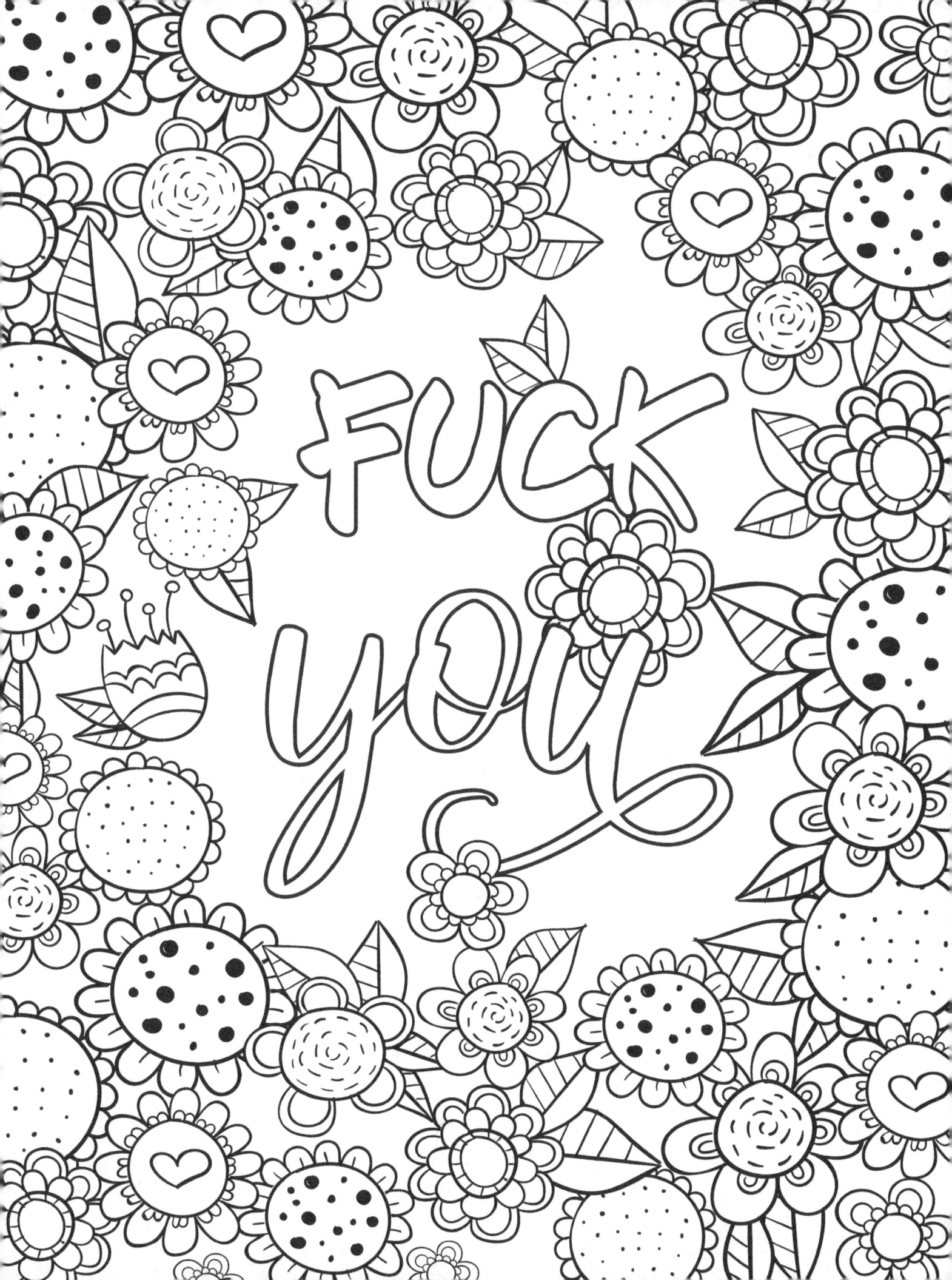

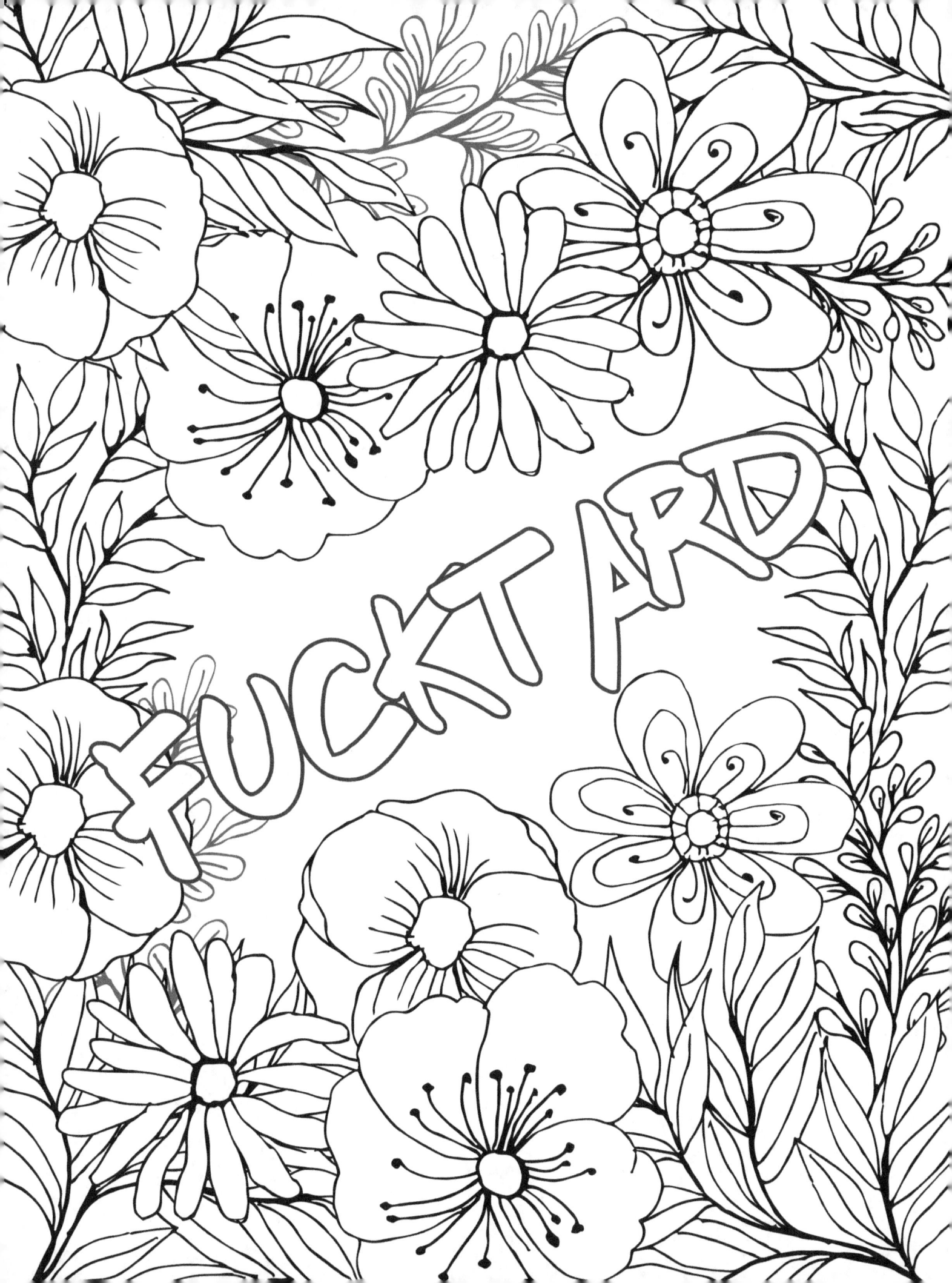

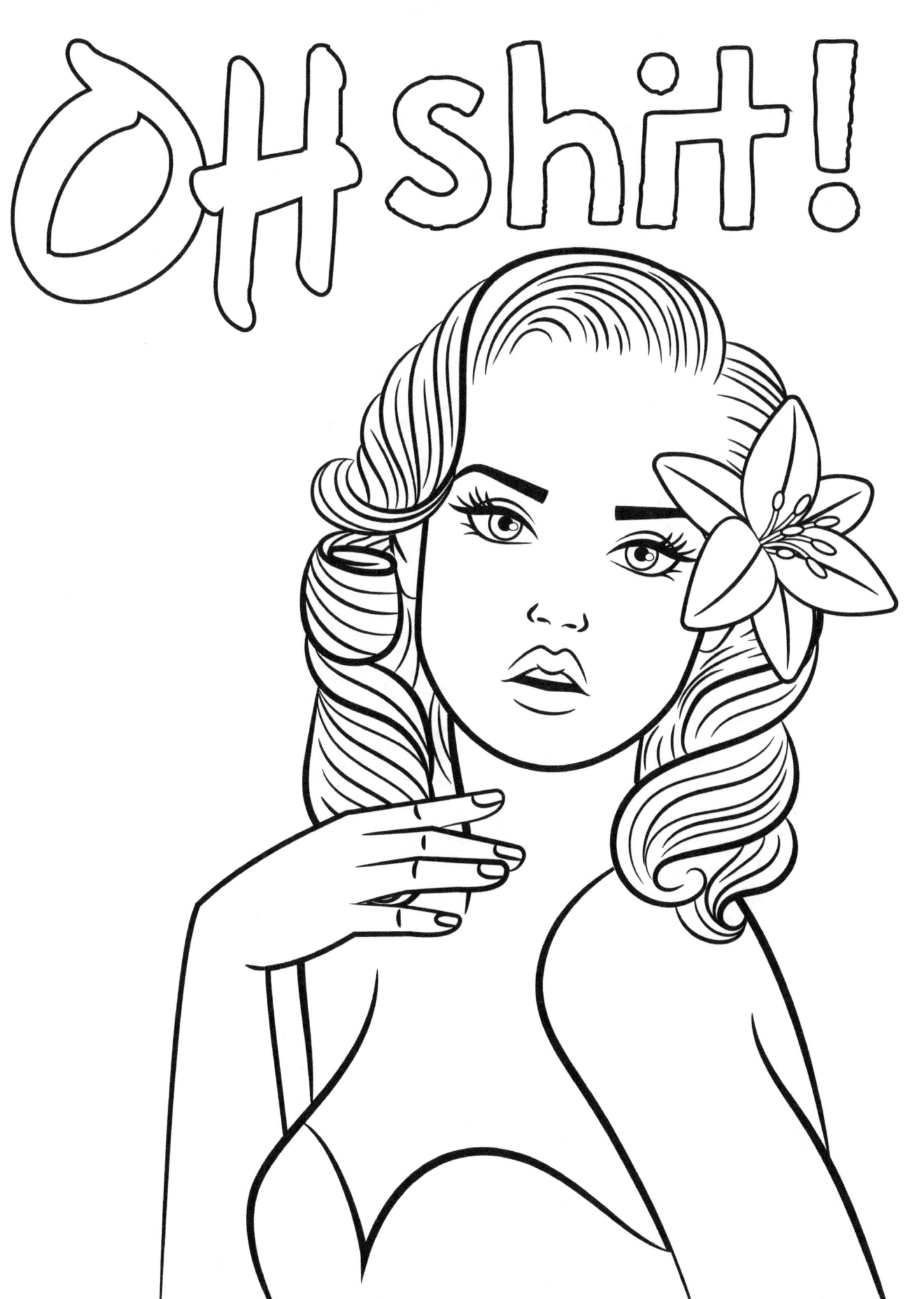

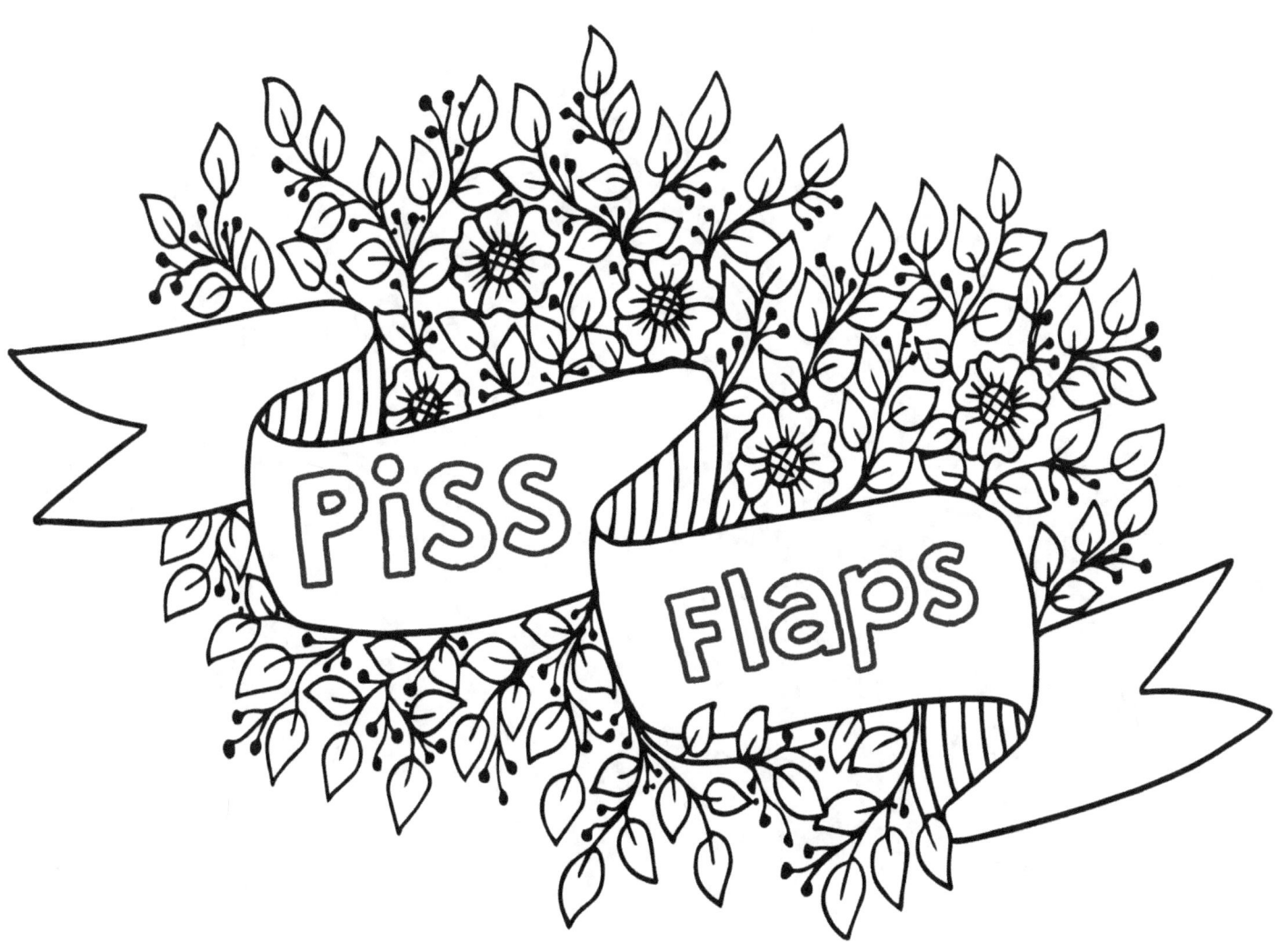

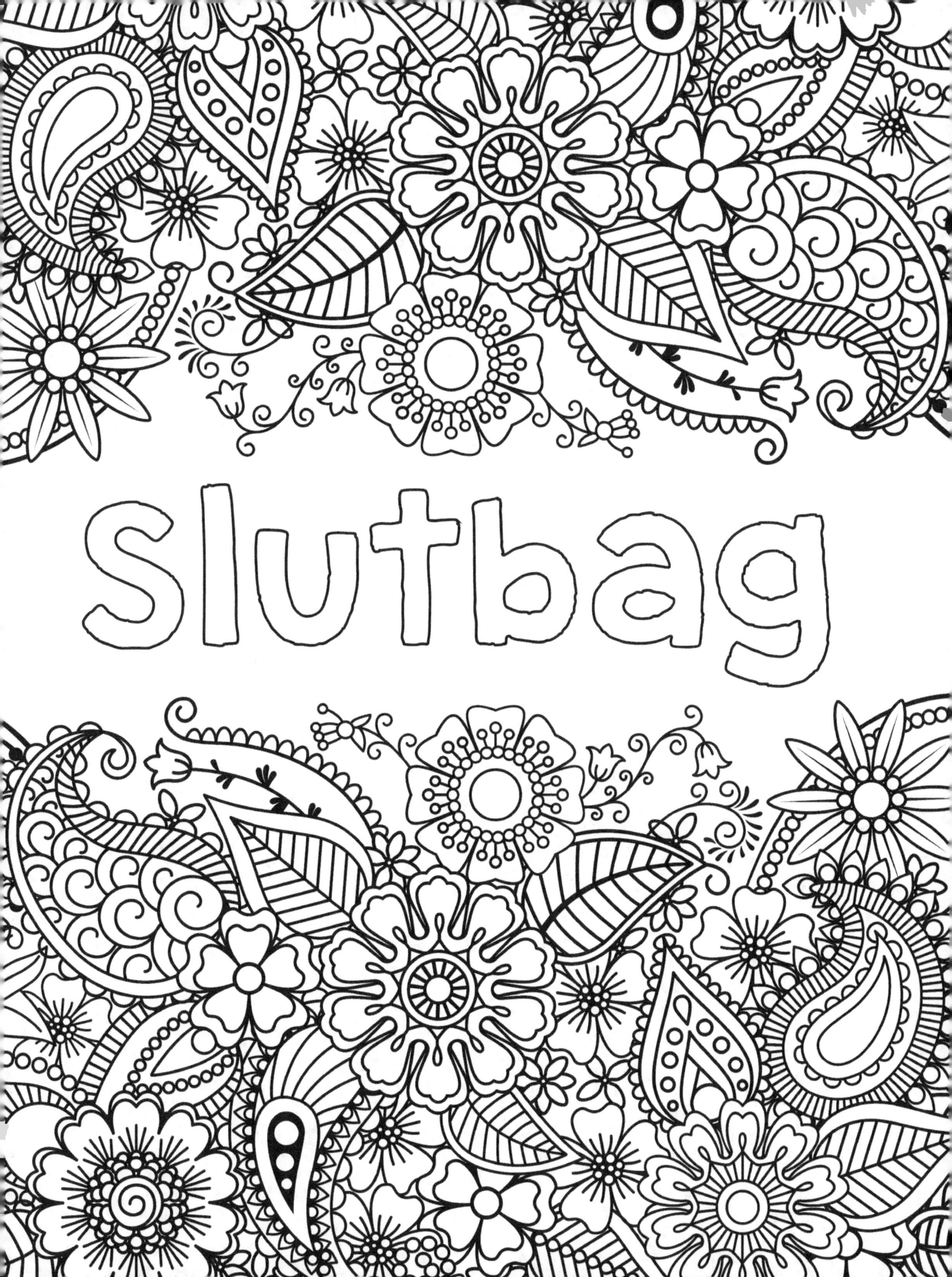

PIECE OF SHIT

Test Color

Test Color

Test Color